THE ERA OF DISCONTENT

THE ERA OF DISCONTENT

poems

BRIANNA NOLL

ELIXIR PRESS
DENVER, COLORADO

THE ERA OF DISCONTENT. Copyright © by Brianna Noll.
All rights reserved. Printed in the United States of America.
For information, address Elixir Press, PO Box 27029, Denver, CO, 80227.

Book design by Steven Seighman

COVER ART: Chad Wys, *Deletions in Red*

Library of Congress Cataloging-in-Publication Data

Names: Noll, Brianna, author.
Title: The era of discontent : poems / Brianna Noll.
Description: First edition. | Denver, Colorado : Elixir Press, [2021] |
Summary: "Winner of the Elixir Press Poetry Award"-- Provided by
publisher.
Identifiers: LCCN 2020048534 | ISBN 9781932418170 | ISBN
9781932418750
(paperback)
Subjects: LCGFT: Poetry.
Classification: LCC PS3614.O4756 E73 2021 | DDC 811/.6--dc23
LC record available at https://lccn.loc.gov/2020048534

ISBN: 978-1-932-41817-0

First edition: TK

10 9 8 7 6 5 4 3 2 1

for Chris, always

Table of Contents

II

III

Acknowledgments

Many thanks to the editors of the following publications in which these poems first appeared, sometimes in slightly different form:

32 Poems, "Too Much Power to Wear in Our Buttonholes"
Another Chicago Magazine, "Espionage" and "You, Confessor"
Burnside Review, "Cradle Song" and "What Color Is Your Aura?"
Carolina Quarterly, "Breaker" and "The Fir and a Bramble"
Cincinnati Review, "Imposition"
Crazyhorse, "Radioactivity"
Green Mountains Review, "Perenelle Flamel Contemplates the Cosmos"
Jet Fuel Review, "The Art of the Insult"
The Journal, "The Distant Relative Who Calls at Midnight"
Kudzu House Quarterly, "The Will Is Not So Easily Contained"
Matter, "A Young Ruler in Wartime" and "Someone Breathing Is a Sign of Order in the World"
Mid-American Review, "The Boreal Forest" (as "Boreal")
the minnesota review, "Beyond the Vanishing Point"
The Missouri Review, "The Collective Unconscious"
Phantom, "Speculative Grammar"
Prairie Schooner, "Mountains Are Mountains"
Willow Springs, "Landscape as Reliquary"

Introduction

In the Before Times, it was fashionable to approach the apocalypse with wry detachment, with a bit of wink and a nod (provided, of course, that you weren't a doomsday prepper). But now that we find ourselves doom-scrolling through a raging pandemic and equally virulent news cycle, it feels like we've quite possibly reached peak dystopia. We need something else—and Brianna Noll's fabulous (and fabulist) poems are a necessary, potent antidote for our time. "Making art is the making of galaxies," she writes, imagining the alchemical transformations contemplated by legendary seekers of the philosopher's stone.

The Era of Discontent acknowledges the apocalyptic as a timeless metaphor deeply embedded in cultural thinking, one arising from specific theological contexts of millennial fear that suitably frames our anxieties. "To the Radio Nurse" takes as its subject Zenith's 1937 electronic baby monitor—a stylish Bakelite sculpture by Isamu Noguchi that resembles a human head, commissioned by the company's president in a time when the Lindbergh kidnapping would have still been fresh in mind. Noll aptly captures the uncanny nature of the object and its creator's fusion of the biological with the mechanical, imagining "its shadows arranged in/the likeness of a face—/a little citizen, a little survivor in the dark." "How to Give Birth to a Rabbit" looks to the eighteenth-century fascination with monstrous births and the cultural phenomenon of hoaxes, with a keen eye to the physical predicament of Mary Toft, the historical figure whose room was filled "with onlookers willing/to pay for your oddity,/to ogle"—spectators whose curiosity allowed them to ignore grimmer realities that the poet, addressing Toft, honors:

> …your miscarriages, your
> empty salt cellars and
> candles reformed from
> their drippings, which alone
> mean little but add up to
> a fervent kind of desperation…

Though attentive to the vagaries of human perception, Noll's verse pays tribute to the quest for transcendent meaning that colors contemporary life: from Kodachrome screen tests that render female subjects "translucent" so they become "not a figment but a form/that, like light reveals/what lies behind the scrim" to colorful auras that appear to their observers "ineluctable/ but changeable."

In "Late and Soon," Noll muses on end-times exhaustion, unpacking familiar tropes of disaster that prompt her to seek *"the afterwhere"*—

> a future more beautiful
> than ominous: feathers
> bolting through the folds
> of a paper crane, its
> new-muscled heart
> fluttering as its airfoil
> wings find wind and lift.

Whether she turns her attention to linguistics, art, or natural history, Noll's verse is luminous and precise, bringing a skeptical eye to the world of appearances and the systems of thought we've created for understanding it. "Radioactivity," for instance, reminds us of the invisible laws that govern the universe, one where

> [u]nintelligible parchments
> tell of dropletons, a new state
> of matter, a quantum fog
> that ripples like water…

Such knowledge doesn't quench the poet's search for beauty; she notes how the impulse to garden, that act of cultivation, offers its own magic:

> …We tend
> the rose with powdered eggshells
> because we want to watch its light
> bend into more and more
> impossible shapes…

The Era of Discontent is populated with scientists, saints, artists, and visionaries such as Bartholomaeus Anglicus (the medieval scholar whose writings advocated the belief that we come to know the Creator through creation), Christine de Pizan, the medieval writer and historiographer whose works offered early critiques of patriarchy, and nineteenth-century natural theologian William Paley. Noll's formal versatility, too, is evident in poems like "A Mathematics of Air" (a pantoum which takes on the possibilities of environmental collapse) and "Midwinter Villanelle," which explores metaphors that elide and illuminate the season. "We know the truth of it," she observes, "the way it seeps//through cracks in floorboards thin as crepe."

Elsewhere, the poet's reflections on the natural world interrogate our complex relationship to the environment and offer a glimpse into deep time; such concerns are viewed through a fabulist lens that underscores their powerful reach. "Speculative Grammar" reveals a post-apocalyptic world where oppression persists because metaphors of nature no longer inspire hope: the extinction of birds leaves its populace "more or less/indifferent to our groundedness/as we could never be about /conjugation." Though she elegizes what we've lost, Noll also acknowledges the promise that results now that "our dominion is denied us" ("Elegy for the Ground We Walk On"). We might fashion new words for "a world we do not shape/to our will, but shapes itself—more pliant than we'd ever believed." Brianna Noll keeps her eye on the clock and the compass of creation. *The Era of Discontent* is a timely and terrific volume that offers an urgent reminder that poetry is a corrective and healing balm.

—*Jane Satterfield, contest judge*

constant change figures
the time we sense
passing on its effect
surpassing things we've known before
since memory
of many things is called
experience
but what of what
we call nature's picture

—LYN HEJINIAN, "constant change figures"

It is one of the peculiarities of the imagination that it is always at the end of an era.

—WALLACE STEVENS, "The Noble Rider and the Sound of Words"

I

Perenelle Flamel Contemplates the Cosmos

When the shadows look to you like sheets
of tin and the light like sodium flame,
you'll know even God is an alchemist.

One day, we'll discover a planet
where the rain is made of glass,
and we'll remember that everything

shares constituent parts, *materia prima*.
I have the makings of glass, of earth,
in the fist of my heart. I have a soul

of gold, and gold a core of blood.
Making art is the making of galaxies,
the astronomy below. But transmutation

is a cathedral where the spirit learns
its true nature, the hand of God
the philosopher's stone making us glow

bright and fervid as stars because we are
stars, and all we need is a catalyst
to reveal our common, our hidden, glory.

Epistemological Snapshot

This world has been made with a ruler. This world
has been made with sacred fire, and we are formally
greeted with tempered flames diffused through branches
of Norfolk island pine. Our first sight is burgundy,
the light on our eyelids, but this tells us nothing
about how angular things are. We find ourselves
in a room, in a hospital, in a town all grids. Beyond,
the trees are brownish lobes sprouting vectors, and the math
is immense. But you know this already. You are not
the just-born. You are a person grown, though youthful
in your penchant for tee shirts and hoodies and bowling.
You know you cannot know what actually exists—
you're just tired of the same old stories. You want to dream
a red couch and a ragdoll cat and make them both appear.

To the Radio Nurse

I think of you as a woman
who thinks herself a violin,
like the Man Ray portrait
repurposed as a voice
ridged and reaching.
There are a lot of young
girls in the museums
imagining their bodies
hollowed, their heartbeats
amplified with the help
of their newfound f-holes
or the rosettes of a lute.
You've progressed beyond
such a simple transformation.
Sightless, you monitor
a space that breathes,
its shadows arranged in
the likeness of a face—
a little citizen, a little
survivor in the dark.
You shout its small shouts,
acciaccaturas you execute
delicately, as though with
nimble and accustomed
fingers. But you are pure
sound—I only think of you
as a woman. Your eyes are
the static your perceptions
interrupt. I imagine sleep
is like this—not silent but
formless, synapses misfiring,
confusing the senses.

How to Give Birth to a Rabbit

after Mary Toft, 1726

Pull the snuffling bunny
out from under the folds
of your skirt, your stomach
convulsing in labor,
or what you call *the leapings.*
Have a midwife nearby
to confirm. Fill your tiny room
with onlookers willing
to pay you for your oddity,
to ogle, to right you in the end.
This makes you a monster,
of course. Tread lightly.
No one will think about
your miscarriages, your
empty salt cellars and
candles re-formed from
their drippings, which alone
mean little but add up to
a fervent kind of desperation.
It's only a hoax if they doubt
the possibility of a rabbit fetus
slicked with human afterbirth,
if they think you *sullen and
stupid.* The rabbit was not
engendered there, not really,
but it does emerge, head-first,
like a right and proper child.

We're So Much More Alive in Color

Kodachrome, 1922

The lights flicker and your
ribbons flicker like
chrysanthemums reflected
in algae-thickened ponds.
This is your screen test—
the unsteadiness rolls out
of the negatives, frame
by frame. There's so much
red to be played with,
so much cyan to splice,
to burn. You gesture
as though your hands
were water, were running
deer in the brush.
The film cannot capture
your voice, not yet, but
that doesn't keep you
from speaking. We can read
your lips, the words pouring
sunshine, punctuated
by dust, by fine tears
on celluloid. This is how
we can tell you're human:
your movements recall
our fondest memories
of nature. After a while,
you become translucent—
not a figment but a form
that, like light, reveals
what lies behind the scrim.

What Color Is Your Aura?

Mine takes the shape of a dog.
My dog, in fact—ginger
and timid, who must disagree
with Emerson's premise:
very seductive are the first steps
from the town to the woods,
but agree with his conclusion:
the End is want and madness.
Fear is an endless want.
Fear has its own aura—putrid
and flickering, clearest
at precisely eight minutes
past dawn. We never expected
there'd be so many men,
so many auras so
motheaten. The town can be
as wanting as the woods.
An aura is ineluctable
but changeable. I'd venture
the dog's true aura is the color
of a hamhock, or deeper,
like cockscomb. As it is,
it's as altered as ours.

Late and Soon

When I say *I'm tired,*
I mean *the world*
is too much with us, or
I'm looking for
the afterwhere. It's all
heavy on the eyes,
what with avalanche
and typhoon, redwood
and mesa hanging
dreadful above. And
we don't need a storm
of mackerel raining
upon us to know
there's something
suspicious in the gun
library, shadows threading
the well-oiled stacks
mimicking the sound
of helicopter blades.
We know what comes
next—it's a trope,
even if we forget which
war it was that taught us
to fear man-metal alloys.
We want to imagine
a future more beautiful
than ominous: feathers
bolting through folds
of a paper crane, its
new-muscled heart
fluttering as its airfoil
wings find wind and lift.

The One and the World

We are wicked when we act alone.
Only singular could we hope to steal
an airplane or a Stradivarius, display
the self with such violence. Yesterday a cord
was slipped around a conductor's neck so
a man could steal his antique violin—a man with no ear

for timbre, for tone. Or maybe *because* of an ear
for music—how can we know? The conductor, alone
and broken in a Wisconsin parking lot, so
long exposed to cold, bloomed hoarfrost and lived. Steel
yourselves against nature, against the telltale chord:
in the tritone, the devil displays

his virtuosity, a malefic display
of his solipsism. Maybe that's it: the ear
is the means by which evil cords
itself to us. We're most vulnerable alone,
and, shaken, we listen. Don't let the music steal
you away. Don't forget: there's so

much that's alive in us, and so
much sunlight to green: we are ecosystems on display.
Embrace your multitude, and no one could steal
it from you. Yesterday, a man was corrupted by his ear;
a century ago, by his eyes. He would've been alone
on a ship, nostalgia leading to calenture, a cord

lassoing the mind to nature, a cord
lassoing the mind to nature beneath the sea, so
powerful he jumps into the watery pastoral, alone.
Solitude can lead to terrible things. We try to display

our best selves, but we can't help what we hear,
or see, or imagine. Even the snore of a river can steal

us from our right minds. Steal
what you will from philosophy—we all do—its cord
is tight and logical. Think of your ears
as filters: discern what's real so
you don't fall trap to humming temptation. Play,
but don't feel you have to go it alone.

Alone, you cannot know what force might steal
your senses, display the world askew. Make an accord
with the wind so it's less like to tempt your ear.

The Art of the Insult

Artless, bloat-kidneyed gibbet.
Cudgel, implement of pain
and death, how you lash.
What a lovely container
you are, shrouded in the old
razzle dazzle: a trick—a delight!—
a trick. In the end, you're
just a hologram, and I stick
my finger through your eye.
This is how we demean.
We wee lads and lasses—
we can be such worms, burrowing
for devices to widen the space
between us, turn nouns
to verbs: *fistulas* to *festers*.

On Superlatives

What's the loudest
word? Is it *fireworks*
or *fuck*? We say
louder, louder, louder,
louder because
there is no *loudest.*
This is a world where
men queue on the roofs
of skyscrapers to jump.
This is the world
we live in, so we feel
responsible, try
to shout, to save
them, but our words
are too quiet to break
through the sound of
the wind in their ears.
When words don't work,
some try shouldering—
a strength rises in them
and they scale down
the buildings, the men
on their backs, fingers
wearing divots into
the scant edges
of bricks. When I see
this weight-bearing,
my eyes sting
as though the wind
has picked up again.
I break at the thought
of such goodness, and

I'm sure that a shared
burden must be louder
than any cry—
the loudest thing
in the world.

Aesthetics for Toxic Times

This is the era of building
and taking apart, our landscapes
and skylines changing, shaken
as the tectonics of the moon.
We pulp our knucklebones clawing
down skyscrapers, run the blood
across our brows and into our hair.
From blimps we drop methods
of destruction, to explode
what we cannot implode.
In the dust that rises, the sky
reluctantly engages in a perpetual game
of hide-and-seek, so we've begun
to think of the universe as a cauldron
boiling madly away. Forget empiricism—
we make what we want to know.
And what's next? We can only raise
and raze so much. This isn't hyperbole—
we're terrified of entropy, of the world
as it once was. This is the era of discontent,
where imagination's gone mad, a canoe
set adrift in Styx carrying the intractable
dead, who can't help but catch a glimpse
of Charon, forgetting, of course, his malice,
his keen gaze. When we topple the craft
before we think to pay our coin for passage,
who do we doom to wander unmoored?

Specter-Men

What is it about the lacquer's sheen, liquid
pigment, that draws the eye in the entrance hall
to the panels and not the full-length mirror or
the foyer door? The room's designed to orient
the guest and read, like an English book, from left
to right. You can't help but follow the panels'
gleaming tour through thumbprint hills the green
and blue of swirled insect shells to the crude
line drawing, lower-right, of men
meeting on a bridge. It's easy to
forget them, spare as they are, when the border is
nashiji—flaked with gold to mimic
the skin of a sand pear. A placard tells
us that a fox hides within the mottles,
a single copper flake. All this attention
we pay a phantom fox obscures the human
hands too splotched and swollen to pick it out.
The lacquer's poison. In his rush to meet
demand—he must paint twenty coats—the crafts-
man's skin blossoms fiery welts, *nashiji*
on knucklebones and flesh. Of course our eyes
are drawn to the sheen of lacquer that seems still-wet:
we're drawn to beauty that exacts a price.

Beyond the Vanishing Point

In a single-line
drawing there is
no beginning and
an end only
where your own
eye stops tracing
the path of the
artist's hand.
The wind can do
this, too—tear
tunnels through
forest canopies or
rake patterns into
sand. What we don't
realize is the prevalence
of line. Think of
the gaze of a woman
hanging clothes—
distracted by some
noise, she looks out
beyond the damp
sheets, through
obstructions, her own
hyperopia. Work
through the eyes'
deficit. How far ahead
does the wren look
when it flies?
How far the hawk?
We web the world
with line.

Shifting Frames

One day, you tell yourself, the paw print
on your manuscript will find its way
into a museum or a light non-sequitur
news story. It's hard to tell what people might
value. Remember, *Boléro* was to be a ballet
before it wasn't. Remember the rhythm
of *Boléro* has been compared to the rhythm
of lovemaking, but don't let yourself be
thrown by those triplets. That's part of the fun,
like shouting *Hosannah* from the cat's cradle
bridge and listening as the sound falls
into the gorge below; your prayer warps in echo.
Stay for one measure, for one finger of bourbon,
soon become five, and we'll watch the light slip
off the brick pressed against my kitchen
window and into a thin alley I know is there
but cannot see for parallax. It's why we're told
to mind the gap—the distance between traincar
and platform gapes when we shift our heads,
distracted. In that sliver of open air,
you are just a face in profile, a leg lifted.
In that space, you are vulnerable; you catch
the light in your hair, and as the doors
close behind you, it scatters.

Chron

This bridge cuts through a birch
forest: planks cupped
in a palm, pale wooded fingers
threatening to tighten into fists.
To cross is to surrender. White
trunks play tricks with the light—
it's always daylight here.
It's always the same moment—
the foot about to step onto the bridge,
the eye noticing how orange the fallen
leaves. Something about hell.
Something about a hand-basket.
Mineral deposits in your hair track
where you've been, thinnest
travelogues. Time is something
we parse, and here is where
you've stopped. You have a choice:
cross, or turn back. This will be recorded.

Isolationism

Can we say that, at one time
or another, we've all seen an owl
open its mouth, even if we never
heard the screech? Haven't we all
watched a flame fall into water?
This kind of movement
demands the eye's attention.
There's a cicada whirring, right
now, because it's September,
and it knows it has little time left.
It's not calling to us—we are
incidental—but we're drawn
into the crest of the sound, then eased
out of it, whether we notice or not.
But I worry we've otherwise become
strangers in our own worlds,
and isolated in turn. What do we hold
on to when the world around us
fades at twilight? There's little and less
to grasp when our eyes, so used
to light, must acclimate to the dark.

One and Three Crows

Feed them, and you'll be
rewarded with sea glass
and buttons, tungsten
filament and the head
of a rotted crawdad.
Don't let thoughts
of currency or equivalence
hinder your social conscience.
As with any orthodoxy,
consistency is key.
You give, and they give,
and we can forget talk
of *unwelcome species.*

You will be doubted
when yards swarm
with quarking and feathers
but not gifts, your reciprocity
mistaken for worship.
You'll wonder:
How do you prove intent?
and *Must a gesture always
be witnessed?* Even the eye
can't be trusted: the ancients
called the ocean *wine-dark*
and the sky *white.*

Could you picture a crow
if you haven't seen one
in days? The phantom crow
is the shadow of an airplane
you try to wrangle

from the sky. It is a poem
in which crows are
described, but where
no crows could possibly appear.

Imposition

The paper lantern falls in love
with the sky it's wrapped in:
a changeable embrace. The paper
lantern knows it's held up
by a hook on a line, but somehow
the sky keeps it from tearing
despite rainstorms and the threat
of typhoon. The paper lantern
does not know its name
in any language; all it knows
is light and hook and sky.
This is a love that needs no words,
only physics, the illusion of being
buoyed by molecules. As we watch,
we are possessed by our need to say
what we see, to say what we feel,
watching all the time our breath
as though we could be dragons,
as though we could set this all
aflame and be done with it.

Radioactivity

What's the half-life of a rose?
Its glow accordions in fine
origami folds across our
line of sight. It opens wide
and wider as we draw back,
growing translucent but never
faltering. Is it the eye or
the rose that performs these feats?
Unintelligible parchments
tell of *dropletons*, a new state
of matter, a quantum fog
that ripples like water. Maybe
the rose is its own state,
its own absurd navigation project
intent on corralling us, keeping us
from being distracted like moths
by the smell of garbage in the hot
summer afternoon. We tend
the rose with powdered eggshells
because we want to watch its light
bend into more and more
impossible shapes. We want
to be startled, to be singed,
without feeling the burning dust.

Thinking Is Bound to Be Unsettling

According to the worldmakers,
it is how we come into presence.
We see an autumn hawkbit and confuse it
for the dandelion; we look for the milk
in its stem and shed something
like a carapace as we find no trace of white
film. This is a different tide, the mind
set to thought: we can reevaluate
our notions of glimmer and slough;
we can blackberry. In this way, someone
can compose a symphony percussed
by airplane propellers and the after-echo
they leave in our ears. It's not the on
and on and on of the daily routine
but a performance—one mind transferred
to many. It's not important that we're
there but that we're listening.
Even if the propellers are hidden,
we can imagine their heft as they slice
the pollen in the air. Most of what we're told
is garbage, and we can laugh at bunglers
who design drones that fail to deliver
our takeout orders to the right address,
but you must admit that what's truly
dreadful is to think of others thinking.
No one knows this better than Hedy Lamarr,
who watched men think and think her daft,
her beauty not a veil but a lead-lined smock.
She was not made any less real
when they turned their minds from her.
No—in thinking on herself, she found a way
to make herself radioactive
without burning from the inside out.

II

The Lake We Call *Medusa*

You must be
a light-bearer,
or the water will
make a statue
of you, calcify you
from the outside in.
Some have dipped
gulls into the lake
and made violins
of their bodies.
A person would make
the perfect string
bass. You are
your own instrument.
You must learn
to cast light
from your fingertips,
your vocal chords,
or better yet, your
pores. The demon
in this water cannot
bear the dawn.

Fear as Siren Song

The boatsman stands akimbo,
shifting weight from left foot
to right, pressing his toes
into the hull of his canoe
so as to balance on water, so as to
get a better glimpse of his face
in the water, so as to say *Bloody*
Mary, Bloody Mary, Bloody Mary,
so as to see if her greyed body
will rise from a lake as from
a mirror, reaching outward until
the act of reaching becomes an arm
extended, a shade made solid and,
if the legends be true, murderous.
Forget for a moment that
the boatsman's a Catholic
as she was; think instead of how
his rocking body teeters like
an arbor vitae in a storm. Someone
once told him *pain was invented*
by a dentist, a means of garnering
a perverse respect, but he disagrees.
Pain is a temptation, something
we must test before we can believe.
Life is a series of such tests.
He still cannot see her face
though he incants her name.
When he was a child, he saw
the Sacred Heart emerge
from a morning fog, a thorn-crowned
organ pulsing light, and he wonders
if it will rise instead of the queen,
a different, more gruesome metonym.

Allegories of Matter and Form

Bartholomaeus Anglicus, *De proprietatibus rerum* (1240)

So. This is the spark and the flintwheel
that sparks. The beginning is fire,
and we've known this at least
since Christina the Astonishing
locked herself in a bread oven
and emerged unburnt. *Mirabilis*:
fire on one shoulder, a universe
of stars on the other, an elemental
psychomachia. The soul's conflict
is the world's conflict: What's light
without heat? What can we stand on
when we learn how earth liquefies?
The paper properties of things
tell only half the story. Look up:
another woman—she is *form*—
floats, a candle in hand. Remember
Christina flew from her coffin
into the rafters of the church
and refused to come down. She had
a choice, to stand on clods of grass
or in waves, but she made herself
a third option: this is a miracle, too.
We've arrived at another beginning.
Do we attempt our own miracles,
or are they just metaphors?
Saints, it seems, are meteorites—
iron honeycombing gems.

Intercession

O patron saint of the gaping maw,
of the filed teeth inside, you've been
watching me squirm, my hair coiled
around my neck, and I don't know
whether you've come to save me
from being gobbled or it's you
who does the gobbling. I'm sure
this is a catechism—I come from
a long line of forgetters who fill
in the blanks with their own
imaginings. I once professed
that sacramental wine was not
the blood of Christ but a liquid
suspension of His hands, and if
you held the wine in your mouth,
He'd trace gospel on your tongue.
I'm no vintner, no theologian,
but I could taste notes of smoke
and parable. What is your name
again? And when is this lesson
going to end? I'm already struggling
to breathe, and you leer and bare
your teeth. Venerable one,
it's one thing to be swallowed—
quite another to be chewed.

You, Confessor

Measure carefully before absolution.
After you peel an orange, you should
feel the pith under your nails, its bitterness
later finding its way to your mouth.
Erasure is no just penance. It's perfectly
symmetrical, the season of outrageous
prosperity and the time of heartlessness,
and there's been a rash of penitents eager
to strip their fingers of limonene.
Let it continue its eldritch burning.
We have grown to accept things
as they are, as though there were
no interior to anything anymore—
hearts, fruits, the billfolds' ominous
thunderclap. The left half of your face
better reveals your true feelings,
but the brain is gesture and metaphor,
the screen in the confessional barely
a screen. They sit in profile—they cannot
face you—but you are a seasoned
confessor. You can hear the cues they hide.
Boil an orange in brine and leave it to dry
in the sun: it will blacken and hollow,
but its flavor deepens, a bitter earth.

Forms of Decline

The sheep shear themselves
with little teeth—or did, once.
Our only job was the loom.
But now, skyscrapers crumble
without upkeep. We build scaffolds
like stiff metal skirts to catch
what falls to earth. I'm reminded
of Puritans who named their children
imperatives: *Make-peace* and *Kill-sin*.
How kind, really, or good-intentioned.
I'm so sorry—these are all ways to
avoid saying *I don't remember you*.
It's just—I've grown old, and
my mind is filled with sunspots.

A Clean and Mannerly Insurgency

It's the Feast of the Archangels,
and we take that as a sign. We gather
at the four cardinal points and invoke
Uriel, Angel of Poetry and The Eyes
of God, to help us see how best to grow
old in a place where annunciations
are spoken in the voice of our fatigue.
O, Uriel, can we continue to sleep
by the thousands on the hard earth
in the streets waiting to be noticed?
We've formed orderly lines facing
true north as though holding tickets
for a carnival ride, but here they search
even pigeons for weapons, an affront
to the liberty and dignity of us all.

We're tidy and genuflect southward
in praise of Raphael, Medicine of God,
who daily reminds us how easily disease
will spread from waste. It's not enough
to wash our hands and eyes: waste—
apple cores and cornsilk, gristle
and albumen—rots and ranks, leaching
into the water and the insects
on the water, into all who drink. Soon
the snapdragons will die, their blossoms
wilted into skulls. This is how the muse
steps from us, how we step
from ourselves if we're not careful.

In the commons, in the gallery
of heraldry—in effect, a gallery

of light—we collect and await news
or instruction. We've called out
with our souls to Gabriel, the man in linen,
about the blood and the bloodshed.
There will be a collision of minds
and bodies while we wait. We were
tutored exclusively in physics to squelch
our artistry, but they didn't understand
how much imagination you must have
to envision galaxies and singularities,
the earth in syzygy with the moon and Mars.
This protest is, pardon my language,
a clusterfuck, and we wait and wait
for the trumpet to sound from the east
while we sketch figures with infinite surface
area and finite volume—geometry's horn
of Gabriel. Mathematics keeps us
calm, and quiet, and thinking.

Angelology teaches us that Michael is
long-suffering, like us, and that makes him
merciful. His name itself is a question—
Quis et Deus?—a phrase we know too well,
etched as it is on each of our fingerbones.
We call him *saint* though we never sainted
him, as though he were always pure
grace. But we know the weight
you've carried, Michael, how you, too, sleep
fretfully and look to the cardinal points—
all four at once—for a prophecy of light.
The auroras do not reach us here,
no matter how we call for them,
and the western horizon nightly swallows
the sun. When you weigh our souls,
remember we are descended from giants,

their size in us perpetual if not actual.
Remember that the giants laid out
these mountain roads at His behest.
Like them, we are thought everyday
monsters, but like them, all we want
is peace and liberty, and kindness, now
and at the hour of our death amen.

A Mathematics of Air

Begin with zero, and you can't breathe.
Don't assume the atmosphere isn't quantifiable:
comb through it, and you'll find more than insects
and water vapor—you'll make music of the wind.

Don't assume the atmosphere isn't quantifiable
or that counting is plebeian work.
Rattle water vapor into waves, and you'll make music
anyone can measure and divide and time;

and music is no less if it's plebeian.
How many honeybees can the atmosphere support?
You can measure them, divide and time them:
without a hive to defend, bees are docile.

Calculate honeybees' buoyancy in the atmosphere.
Bees learn to recognize their keepers' faces.
Without a hive to defend, they're so docile
you could cradle a swarm of them in your hand.

There's a formula for facial recognition,
as there's a formula for gravity and force
and how much you can cradle in your hand.
Multiply by i, and see the answer in three dimensions.

The formula for gravitational force
is still relevant when we talk about earth.
Multiply by i to see the air in three dimensions—
it'll make a model to understand the atmosphere.

What is relevant when we talk about earth and air?
Comb through it: you'll find more than insects.
We like to think we understand the atmosphere, but there's
just one constant: multiply by zero, and you can't breathe.

The Will Is Not So Easily Contained

The helium shortage
means no more
balloons, no
more floating
voices. There have
been maintenance
troubles in Amarillo—
the element tugs
at plant ceilings.
Its nature defies
gravity, brings
its container along
for the ride.
What the mind thinks
the heart transmits—
this is wordless—
but sometimes both
need lifting.
What will we do
when the helium
escapes its reserves—
wells that sprawl,
spoked wagon wheels,
beneath the desert?
What will we do
when we know
the ground has lifted
us, but still we feel
grounded?

Someone Breathing Is a Sign of Order in the World

Laurel is slow, a weight pressing
ever more forcefully on a bird's wings,
countering its inexplicable buoyancy
as though gravity were reclaiming the air.
If in the poison garden you are still
breathing, remember: this is a study
to see how a plant kills you, how
it makes you feel before you die.
Chaos: the first creation, a shapeless
heap fighting for order, to be ordered.
So when the galaxy starts dumping
its stars and the sky grows dark
and darker, the darkest we've ever
seen, do we hold our breath?
No—this is the error of control.
Order is not a bomb that decides
whom it kills, but *Chaoskampf*—
the hero's struggle against the chaos
monster. The hero falters, and perhaps
fails, but still her spilled blood draws
oxygen—even when her lungs fail, she
breathes and breathes and breathes.

Erosion

The shipyard tugs
at the tide with arms
like I-beams, trying
to fill containers
with seawater and
sand and the detritus
we leave to wash
ashore. We can be so
distracted, we think
it's the moon
that lures the tide
inland. The eagle
huntress has keen
eyes, and she knows
the truth of things—
our wanderings are
deadly, our buildings
are mad with want,
and we've forgotten
how starkly the facts
have changed.
Now we are remote.
Keep back, we yell
with our posture
from greater distances.
If only we knew
the wolves are
the real heroes,
able to fix the rivers
in their course
and fortify the banks.
They organize

their geography
like mapmakers,
like idealists.
Perhaps the secret is
they lack intent.

A Light That Never Goes Out

The comet we thought dead
was found alive today, trailing
its tail past the sun. Thin
and flickering tail, combusted
core. The sun must overpower
other light sources, lest
we forget its reign, center
of the universe. Even if we
drape all our rooms in velvets,
it creeps in—ambered,
embered—through the seams.
Some might call this *erotic*,
the light undeterred, lapping
every crevice. No—
it's depraved. Desperate.
But this is what makes dusk
so gorgeous: the sun lamenting
its descent, its rays
fingers gripping the land
and slipping. Its last light
on the river's surface—
kawaakari—a handprint or
a conductor—makes the water
a lantern in the dark.

A Cautionary Tale

There's no need
to worry about
the night—here,
grease ignites
cold so the black
glows black
and run-through
with static.
Nothing is
incinerated
in the dark,
or it wouldn't
be dark. What
should concern you
is the light, the
unmanned ignition.
Cogs throb, nerves
bourgeoning, spurring
bolts and levers.
This is how machines
assemble themselves:
first, they must wake.
Don't think dawn
can't wake them.

One of Many Tillers

Because nature is blind, the tiller
must till. Because robots are clumsy,
we must direct its path through
the garden we think of as a hothouse,
the yard we think of as a golf course
of our very own. Because these machines
do the work of humans, we
anthropomorphize them, their rust
an ailment affecting one specific
area of the limb, and we, like medical
illustrators, sketch portraits of their skin
disease, delicate and beautiful, copper
rust blotching tractor red torso and chrome-
plated neck. This tiller is my tiller,
its disease my disease, and as I find myself
with cabin fever, I know the tiller, too,
longs to thrash its way through snow.

January Poem

Sunrise is faint again—
the winter solstice
passed, the dawn slower
in coming. They say
it's an *analemma*, the solar
day and the temporal day
incompatible, a gap in light
and time, named for
the pedestal of a sundial.
The dark drains us, young
and old—we are wound,
antique timepieces,
by the light. My ancestors
mined in such darkness,
the sun absent for months
of days. They emerged
from the earth, each a dark
sunrise: faces coal-
blackened, their eyes dim
lights rising long past dusk.

Breaker

Sort coal by size:
egg, stove, chestnut,
pea. Pick out
shale and stone, but
ignore the earthworms—
they burn clean.
You're always
looking down,
your eyes chutes
your thoughts
fall through.
You don't need
to know clouds
resemble the canopies
of trees. Dust is
a subject with which
you are intimate,
and you devise
taxonomies of coal
sheen. But you're
curious: *What kind*
of bird lays jet eggs?
Watch your fingers,
child. The sky is
in your future.
Just think: when
your spirit takes
the shape of a hawk,
it will have discerning
eyes to terrify
the little and the living.

Speculative Grammar

We arrived when the birds
went extinct. Without models,
we could not learn to fly.
We were more or less
indifferent to our groundedness
as we could never be about
conjugation. Too much
indeterminacy leads to
too vivid dreams—
the potential phoenix,
the subjunctive lynx:
one day, our eyes sparks
of royal flame, we might rise
against those who weaponize
our caring against us;
were our hearts so engulfed,
we could do more than
withstand trespass. But
there are no birds here, no
fireflies, no bull-throated frogs.
Winter returns every year.
With so many indicatives,
hope begins to look like lie.

We Are Shaped From Without

Listen. There's something
tapping out there,
and the body—tectonic—
rumbles at the same
frequency. It seems to settle
the heart in its plate.
When meteorites fall,
we think of golden
tails steady in their
course. We forget
they displace the air
and ripple glass windows
until they shatter.
Still we look for
their fragments stippled
around the nest
their impact makes
in the earth.
The work of change
is destructive;
it's only beautiful
in the aftermath.
Let me put it like this:
you are the wind
made by a horse's tail
swishing, and the real
wind is carrying you
away. It's not sad
to leave the source
of your making—
it's sad to labor there,
alone.

The Pinkertons Turned Us Against Each Other

So when they called us *finks*, we ran. They say in Texas
bluebonnets bloom and wilt so quickly, people run through acres
of fire ant colonies to touch the petals, hoping to leave
the imprint of their fingers as on goldenrod paper. The venom
seethes. There's fear in this kind of thinking—of a life insignificant
or plebeian. But our fear is different. We know how little
our hands are worth, and the Pinkertons have made goons
of us all. We can't help but leave traces of ourselves everywhere,
a constant betrayal. But know that we aren't turncoats—
not intentionally. Just to speak is to inform, and this will be the end
of us. So when we run, we leave our shoes behind. There's always
a siren in the distance wailing some kind of loss. No one wails for us.
All we have left is our surroundings, so we take note. Bats fly
between the branches of tamarind trees, their wings translucent
as screens. If it were evening, they'd make perfect runagates.

With the Flag We Stake Our Claim

It began as a uniform-making session
but quickly became a flag-making
session when we realized we could
not stitch pleats or pockets. We weren't
particularly skilled seamstresses,
and we weren't particularly brave,
but we were fervent supporters
of the new world. The flags
were piling up, and I began whistling
hunting songs, mistaking a jug
of water for a crown of silver
antlers. I looked through the walls
and noticed the absence of birds
in the world, the sky an unprimed
lapis canvas. We used to call it
ultramarine, but now it's just
lapis because we're trying to be more
truthful. *Lapis* because it's made from
the stone and because it's not *more*
than the sea, the sea extreme
or radical, though that was our reason
for choosing it. We imagined a sea rising
and swallowing the troubles and leaving
behind like a giver a world of plenty,
the plants and animals of our dreams.
The flags are lapis. Should we learn to sew,
the uniforms will be lapis. When we die,
and when our animals die, our coffins will
be draped in lapis scented with burial myrrh.

An Army of Ghosts

From the first, we tried to forget
the debts we owed to honor.
We'd been called forth into the horizon,
drowned in its light, and we re-emerged
more weightless than the grassy
herbs we steeped for tea. So rid
of mass, we were able to move
stealthily, and not since Paris
have we remembered what it was like
to have a body pressing into space,
resisting the wind, a body we could
play like a flute alive. When we were
mist, we could seep ourselves
into overhangs and secluded corners,
spy and retain, spy and reconnoiter,
spy and steal ourselves back
into the falling dewpoint. It was our job
to listen without ears, to ascertain
the nature of truth. We began to blink
like cherry blossom petals at midnight,
bright against blue-black branches
in the blue-black night. It was inevitable
we'd teach ourselves Morse code,
but when we started to become
Morse code, it was said we'd soon be
decommissioned. But we were happy
to think we could resign ourselves
at last to quiet shadows. For so long,
we'd been like specters; we were ready
to rid ourselves of the figurative.

Espionage

In the yellow room,
their voices muffled
by women too loudly
touching their pearls,
they tapped *yellow
cake*. They blinked
terror and *plot* and
imminent. They were
journeymen trained
in the art of language
and its stranglehold
on sign. To free
themselves of words
would be to find
a more reputable truth.
So they studied horses'
cues: arched neck,
ears pointed upwards
or back, a sigh
through bared teeth.
But this was a fight
for the sanctity of human
life—there could be no
botched signals—best
to eliminate the human
factor altogether.
They let the horses
become the messages
and the messengers,
the interpreters, too.
It took some letting go,
some long nights in

blue rooms reading
the smoke curling from
their cigarettes like
contrails, but soon,
they let the world do
all the talking.

III

Stargazing Is, Necessarily, Belated

We trace the contrails of the big bang
using a star map, respooling the improbable
gymnastics of light. Remember Ptolemy:
every digression in latitude is measured
from the nodes. Think in parabolas, gravity
born and immediately set to work tugging
matter in contained paths as though through
a fire hose. We date the sprawling galaxy
by shade and tone, aware that by the time
we see a white dwarf it's already burned
out. We're too late for all of this—too late
for any endeavor, really—and we're using
our bare eyes, without help from telescopes.
We'll never discover the lost ellipse
of a distant solar system or black holes
that draw in matter like birdfeeders.
But we remind ourselves we're not
astrophysicists—our purpose is memory,
tracing a chromatic past that insists it's present.

Poiein

"It is only by the display of contrivance, that the existence, the agency, the wisdom of the deity, could be testified to his rational creatures."
—William Paley, *Natural Theology* (1802)

You are in a garden, and you
are astonished. Your blood
is stardust, your nerves stardust
sizzling. In the roughshod locust
tree a colloquy of birds
decouples garden noises—
compartmentalizes wind rustle
and buzz, the faint trudge
of earthworms, into spheres
like conches you could hold
to your ear, one at a time.
You feel you've just
emerged from the mantle
and your soul has come
to greet you, to swaddle itself
in your body, and this garden
is both new and old, as though
you are a machinist looking
closely at the gears of a machine
that replicates an idea you swear
was yours but can't be sure.
When we encounter beauty,
we're struck by something
that resembles memory, though
all of nature is symmetrical
and repetitive. How often
do we ask ourselves
whether we're the machinist
or the machine?

The Collective Unconscious

Some things have been with us
a long time, like the words *spit,*
fire, and *mother,* or the color
black. We are born with them
on our tongues, as we are born
knowing that haloed suns foretell
rain. We share the land and
the language to speak it, but
these commons grow fewer,
and we've stopped trusting
in lore. When we lie on our backs
and feel a flutter in our chests,
we know to sing to purge the air.
But who still believes that if I
conceive a child during the *m-*
months of my thirtieth year,
I will bear a girl? Say nothing
of the strange accuracy of the
prediction—alone and private
we doubt the contents of our
collective coffers. Look backward:
anyone who's seen a ligonberry
has named it for an animal: cowberry,
foxberry, bearberry, cougarberry.
This is the legacy we leave—
truths we feel in each other's bones.

Midwinter Villanelle

Call it what you will: *the stallion sleep*
or *the winnowing time.* These are just names.
We know the truth of it, the way it seeps

through cracks in floorboards thin as crepe;
it latches and compresses and reams.
Call it what you will. The stallions' sleep

is dreamless, and we envy them. The sleet
prophesies at night, plays its games
with the truth of things, seeps

itself—cunning—into our sleeves.
Arms are pillows: sleet spins our dreams.
Call it what you will. The stallions, sleep-

deprived but not sleepless, appeased
it, worshipping fortune's strange
truth. The cold will always seep

in. Best acclimate; even the fire will slip
its ruddy heat. Stir the dying flames:
we know the truth of it, the way it seeps.
Call it what you will. The stallion sleep.

The Boreal Forest

Arboreal, then as now, the thick pine scent
a slow syrup. We could bite down
on the air and chew. The aurochs dragged
their horns through, then trailed long taffy
banners. Not much has changed, really,
though most have forgotten the aurochs—
show them one in a diorama, and they'll
think *cow*, or maybe *water buffalo*.
But everything remains, somehow, waiting
to be translated: pollen cores traced and read,
spooling storied like sediment or tree rings,
deep and back. We make a peat fire and tell
the story of the ocean: it rose from a grain
of salt and, pooling, made isolation, islands.

Landscape as Reliquary

Everything is peach
and gray and graphite
on our search for
the world's oldest
tree. It is dawn,
or almost dawn,
and this color scheme
changes by the minute.
By the time it's rendered
itself gold and gold
and golden green,
we will be too late,
all outlines washed
monochrome. But
there are many ways
to be deceived.
If you're imagining
something like a banyan,
wide and roping,
you're wrong. It will be
thin and salt air pruned
like a bonsai, and
what no one will tell you:
it's a clonal tree, budding
genetic identicals
as its parts die—
a self-made ship
of Theseus, a model
for how to survive.

Plea to the Fleeing Deer

The hart is red,
as you'd expect.
It hugs the curve
of a hill green as
fresh-washed peas
as it runs from us
and our bugle
voices. Our faith
is like a maze—
we follow the deer's
tracks with our eyes—
and its faith is
another maze,
wending always far,
away. It thinks us
nondescript children
wielding the quick
needle, anesthetists
on the prowl. How
could it know
our intent? It doesn't
see us crouch
to tend a wounded
grasshopper or
consider our impact
on the ecosystem.
Sometimes we think
ourselves so important,
so affecting, but
we're running too.
O, hart, we may
seem terrifying,

but we are not
murderers. We just
want to return
in the mornings to
watch the goldenrod
blaze the dawn
fog from the lip
of this valley.

What Is Afterglow, Anyway?

How does light scrawl
its name across a screen
of painted irises when
we know the flowers
are acrylic symphonies
ringing their own
clustered harmonics?
How can we hear light's
whisper, faint beneath
that din? There are inroads
and there are outroads, and
we are all beguiled
by the maps. Here is where
I tell you that irises can't be
purple without light, without
eyes to see them, without
synapse and breath.
This is not bunk, though
we can be so frustrated
by the limiting din.
Somewhere, there are
orchards of dark blue fruit
I cannot name, orchards
that hum a soft glow all
afternoon, only to disappear
at dusk. And somewhere,
farther off, people have
learned to hold light
in their hands, to make it
symphonic, and this is
what we think power
looks like.

The Fir and a Bramble

There's nothing more precious
than mountainglow sprawling
to the farthest end of a forest
or field of clover. From this,
we distill tinctures of stonelight—
a drop of vision under the tongue
to teach the dog his shadow
and quiet the demon's perfectly
reasonable voice. Little creature,
when you believe the world is
a circus act, you don't need to spy
through peepholes or wax
nostalgic to see that anything
is possible. But you will need
help getting over the hurdle
of yourself. Only then can you find
your retinue of waiting birds
to plait your hair and open your
eyes and lift you, like Poseidon
on his war-chariot, above the glow
of the evergreen treeline.

A Young Ruler in Wartime

From a distance, it's hard
to tell whether she is glass
or glassine. In either case,
you might assume her epithet
to be *The Unfortunate*,
but you would be wrong.
Neither is she *The Accursed*.
No, this girl is *Shockhead*,
for no one sees her fragile;
they see her towheaded,
and through her,
lightning bugs seem to glow
with greater force.
No one thinks they're a sucker
for the obvious, but it's so
hard to listen past the mortars
when they fall. Don't think
of her body as a form
perpetually on the verge
of fissure. She will be the one
to labor like a desert dog
to call the last cease-fire.

Sigils

We've run out of fabric—worsted,
burlap, open-weave—so we've
made flags of our fields, burned
away crops into star-shapes
for the rights we've won
and X's for those we're owed.
We don't worry they'll go unseen:
the smell of burning wheat draws eyes.
Besides, the moon is a fox, the fox
a glassine god and righteous.
Each strand of its fur's a blade we pare
into the wood we mold to emboss
our seals. The fox's glory is our glory;
it howls for us, flaps our flags with wind.

Mountains Are Mountains

Just like rhizomes are rhizomes,
even if you call them *creeping*
rootstalks. This is not semantics—
it's a question of being in the world.
When we watch the snow fall, though
it might signal winter, something
bleak or tranquil, we do not forget
gravity or that water freezes
at 32 degrees. Don't think us
unimaginative: knowledge is inlaid
with metaphor, and we invent
narratives for what sleeps beneath
the ice-iron earth. Still, we know
that science can make a lamb
glow green, so we are not tricked
by spectacle. You can process
through town with banners
emblazoned with deer crossing
silver shields, but your bloodied
boots will always betray you.

Too Much Power to Wear in Our Buttonholes

A grand claim, *the most beautiful*
wisteria tree in the world, but hell
if I don't look at it and think *no,*
nothing made can be so lovely.
Its garlands tear the light
into ribbons, and we stand, jailed.
If the wisteria could read this,
it would cover its blushing face.
The perfumer recreates its scent
by mixing bashfulness with light
and linalool. It is a scent we wear
into battle, a scent to rend
the enemy's resolve. Its power is
no secret: we do not bury our dead
beneath wisteria for fear they will
waken with the blossoms in spring.
The perfumer's allusion alone
is potent enough to conjure peace.

This Is Equanimity

This is the moment we remember
smearing our mothers' lotions on our arms
and legs, the bottles aligned like supervisors
in the armoire, their scents powdered
and chantillied. This is how we exchange
pleasantries now—nostalgic flashes rousing scent
and touch, the long-forgotten desire to be elegant
beneath our clothes. So this is how adults really feel.
We escape to the broomcloset, smaller than we remember,
and draw on the walls with soap a pattern of fish
and bubbles. I tell you *Dada* means *hobbyhorse*,
and you draw one with wings and a parachute, flying
or floating from the bubbles you've made into bullets.
How quickly things change. We recall nights interrupted
by the sound of gunfire, the twang of a guitar string
snapping. These stories do not exist somewhere,
stories of blood and robotics, stories that rend
like a terrible prank. We stole our mothers' scents
so we could become like them—poised and protected,
perfume so counter to the smell of flint and fire.

The Distant Relative Who Calls at Midnight

She brings a portable shrine
and opens it at the dinner
table so we could pray
for the gods to forgive
her late arrival. We also
pray for peace because
it's the one thing we all
want, despite it being
a phantom lost in the night
or a mouse we know
only by its retreating tail.
The shrine is tiny and
intricate, and we burn
candles to warm its concave
insides and build shadows
upon flickering shadows
at its heart. This relative,
let's call her *cousin*, reminds
us of the things we've
forgotten. She calls eggplants
aubergines and tries to make
her own diamonds by pressing
coal beneath a complete set
of print encyclopedias.
We don't wish to shake
her hopefulness. We
remember our grandfather
had gold-rimmed pupils,
like hers, and double-jointed
shoulders. When we see her
walk down the dark hallway,
her hands brushing the walls,

we remember the script
of the Catholic mass, the call
and response, the darkness
inside the tabernacle, where
we were told a light shines
more alive than any man.

Christine de Pizan Contemplates Acts of Devotion

And in the distance,
a thundercrackling shakes
the needles from the pines
and rouses us all from sleep.
And in that distance
a finger beckons, or a finger
pinches tight the thorax
of an insect not unlike
ourselves, small and strange
in the larger scheme of things.
For so long we believed
in the anger of the gods
and sacrificing ourselves
or other creatures to quell
their wrath. There once
was a man, or maybe
a woman—it doesn't matter—
held deep below the earth.
From that oubliette—that
forgotten place—this man
or woman chanted not
for freedom but for the love
of gods unseen. This
I understand. If it were me,
I'd pray to lift the hatch,
send up my heart to Venus
a valentine cutout, a red
construction—love
to worship love. I'd pray
until my words lifted
the latch that kept the sun
from my face and my heart
rose, fiery, singing.

Avoiding Cold Feet Down the Aisle

The aisle carpet will be red,
will be plush, and you will
consider its likeness to mud
or sponge; you will hear echoes
from the rectory, echoes
that sound like warnings,
like Christ himself warning
that marriage is fine, yes,
but not necessary—*look at me,*
for example—and you will imagine
that this echo is a kind of musical
fractal—like blood vessels
or neurons, biological feats
of design and function—
ferrying the echo across time
and space in a self-similar pattern
without a center, though you're
at the center of it all, the sound
reaching your ears first and loudest;
but there is no echo, there is just
the voice in your head, the same one
you hear when peeling parsnips
or contemplating the texture
of a bat's ears—like a dog's
but thinner?—and you imagine it's
fractal, but it's not—it's as arbitrary
as all the mind's processes—
and all you need to do
is turn it down, like the knob on a radio,
because doubt is normal, because
only nature is so neat, and you,
my dear—you are human.

Lost Honeymoon in Fire Season

They say the cypress is wick,
as in alive, but we hear *a* wick,
as in a lamp, and we worry for the deer.
Let's start from the beginning:
you cut the second button from
your uniform, pressed it into my hand,
told me it was charged by your heartbeat
and would never grow cold. When
we shed our uniforms forever, a deer
came up to us in the street and bowed.
Now we're called *Artemis of the Wildland*
or *Arrow-shower,* though we've never
hunted in our lives. We share these epithets
as we share a certain bravery and your
heart-button. The deer are our deer now
and wildfires rage, but we are insignificant
without our ribbons across our chests.
We think of the cypresses, we will
them wet, but the fire spreads indistinguishable
from sunrise. This, they tell us, is the form
fear takes for newlyweds, for gods in the wild.

Cradle Song

Imagine, in the Aeolian mode,
you are plucked from your crib
by a peregrine falcon
who mistakes you for another
of its royal progeny
and you grow up to be an aerial
monarch, a fearsome shadow.
Or, if we recall that tiny particles
can ignite, you might wake
to find you've become
light itself, each of your cells
its own flame, tiny homunculi.
Here, where someone always
comes along to bury the dead,
we'll look for you in the most
impossible dark crevices.
Even if we did find you, you'd
be so changed—would we
have the right to call you ours?
A ship remade is still a ship,
but what of a ship made light?
These stories abound:
I am ancient in my fear,
and you are infinite possibility.

Elegy for the Ground We Walk On

Hurry, the field is folding
itself up, a blanket laundered
for storage, and we're to be
caught in the creases. Don't
lose your footing as the earth
tears from the earth
and upends the grass, first
skyward then down, greenest
bed of needles. We called
ourselves *foxcatchers* and
paraded through the forest
our dominion over the forest
until all the creatures cowered.
Now, suddenly, our dominion
is denied us, and we must accept
this loss with a kind of grace
we'd previously ascribed only
to gods and saints, but we will
not ascend to majesty—instead,
echoes of our footsteps will puddle
in the streets—should we escape
this folding labyrinth—and not rise,
resounding, as they always have.
This need not be a disaster:
we could better cultivate our sight,
unclench our hands, and learn new
words for a world we do not shape
to our will, but shapes itself—
more pliant than we'd ever believed.

BRIANNA NOLL is the author of *The Price of Scarlet* (University Press of Kentucky, 2017), which was named one of the top poetry books of 2017 by the *Chicago Review of Books*. She is poetry editor of *The Account*, which she helped found, and her poems and translations have appeared widely in journals, including the *Kenyon Review Online*, *The Georgia Review*, *Prairie Schooner*, *Crazyhorse*, and *Waxwing*. She lives in Los Angeles.

ELIXIR PRESS TITLES

POETRY

Circassian Girl by Michelle Mitchell-Foust
Imago Mundi by Michelle Mitchell-Foust
Distance From Birth by Tracy Philpot
Original White Animals by Tracy Philpot
Flow Blue by Sarah Kennedy
A Witch's Dictionary by Sarah Kennedy
The Gold Thread by Sarah Kennedy
Rapture by Sarah Kennedy
Monster Zero by Jay Snodgrass
Drag by Duriel E. Harris
Running the Voodoo Down by Jim McGarrah
Assignation at Vanishing Point by Jane
 Satterfield
Her Familiars by Jane Satterfield
The Jewish Fake Book by Sima Rabinowitz
Recital by Samn Stockwell
Murder Ballads by Jake Adam York
Floating Girl (Angel of War) by Robert
 Randolph
Puritan Spectacle by Robert Strong
X-testaments by Karen Zealand
Keeping the Tigers Behind Us by Glenn J.
 Freeman
Bonneville by Jenny Mueller
State Park by Jenny Mueller
Cities of Flesh and the Dead by Diann Blakely
Green Ink Wings by Sherre Myers
Orange Reminds You Of Listening by Kristin
 Abraham
*In What I Have Done & What I Have Failed
 To Do* by Joseph P. Wood
Bray by Paul Gibbons
The Halo Rule by Teresa Leo
Perpetual Care by Katie Cappello
*The Raindrop's Gospel: The Trials of St.
 Jerome and St. Paula* by Maurya Simon

Prelude to Air from Water by Sandy Florian
Let Me Open You A Swan by Deborah Bogen
Cargo by Kristin Kelly
Spit by Esther Lee
Rag & Bone by Kathryn Nuerenberger
Kingdom of Throat-stuck Luck by George
 Kalamaras
Mormon Boy by Seth Brady Tucker
Nostalgia for the Criminal Past by Kathleen
 Winter
I will not kick my friends by Kathleen Winter
Little Oblivion by Susan Allspaw
Quelled Communiqués by Chloe Joan Lopez
Stupor by David Ray Vance
Curio by John A. Nieves
The Rub by Ariana-Sophia Kartsonis
Visiting Indira Gandhi's Palmist by Kirun
 Kapur
Freaked by Liz Robbins
Looming by Jennifer Franklin
Flammable Matter by Jacob Victorine
Prayer Book of the Anxious by Josephine Yu
flicker by Lisa Bickmore
Sure Extinction by John Estes
Selected Proverbs by Michael Cryer
Rise and Fall of the Lesser Sun Gods by Bruce
 Bond
Barnburner by Erin Hoover
Live from the Mood Board by Candice Reffe
Deed by Justin Wymer
Somewhere to Go by Laurin Becker Macios
*If We Had a Lemon We'd Throw It and Call
 That the Sun* by Christopher Citro
White Chick by Nancy Keating

FICTION

How Things Break by Kerala Goodkin
Juju by Judy Moffat
Grass by Sean Aden Lovelace
Hymn of Ash by George Looney
Nine Ten Again by Phil Condon
Memory Sickness by Phong Nguyen

Troglodyte by Tracy DeBrincat
The Loss of All Lost Things by Amina Gautier
The Killer's Dog by Gary Fincke
Everyone Was There by Anthony Varallo
The Wolf Tone by Christy Stillwell